Lettering & Calligraphy

ABCDEFGH
IJKLMNOPQR
STUVWXYZ

And O, ye Fountains, Meadows, Hills and Groves,
 Forebode not any severing of our loves!
Yet in my heart of hearts I feel your might;
 I only have relinquished one delight
To live beneath your more habitual sway.
 I love the Brooks which down their channels fret,
Even more than when I tripped lightly as they;
 The innocent brightness of a new-born Day
 Is lovely yet;
The Clouds that gather round the setting sun
 Do take a sober colouring from an eye
That hath kept watch o'er man's mortality;
 Another race hath been, and other palms are won.
Thanks to the human heart by which we live,
 Thanks to its tenderness, its joys and fears,
To me the meanest flower that blows can give
 Thoughts that do often lie too deep for tears.

From 'Intimations of Immortality' — Wordsworth

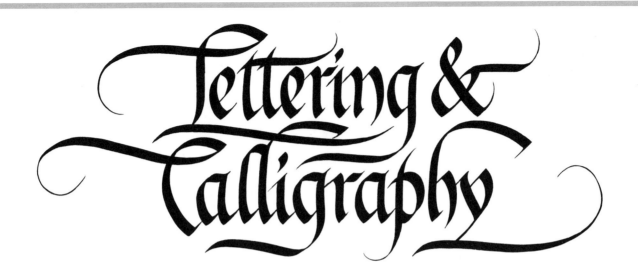

Lettering & Calligraphy

Joan Freeman

ARCO PUBLISHING, INC.
New York

Savitri Books Ltd would like to thank
The Society of Authors as the literary representative
of the Estate of Rose Fyleman for allowing the poem 'Mice'
to be reproduced. Thanks also to Doubleday and Company, Inc.
('Mice' from *Fifty-one New Nursery* by Rose Fyleman)
Copyright 1932. Reprinted by permission of the Publishers.

Published 1984 by Arco Publishing, Inc.
215 Park Avenue South, New York, N.Y. 10003

© Joan Freeman 1984

First published in the United Kingdom
in 1984 by B. T. Batsford Ltd., London

Library of Congress Cataloging in Publication Data

Freeman, Joan.
Lettering and Calligraphy.

1. Calligraphy. 2. Lettering. I. Title.
Z43.F77 1984 745.6' 1977 84-6163
ISBN 0-668-06193-6

Edited and designed by Mrinalini Srivastava
Produced by Savitri Books Ltd
71 Great Russell Street
London WC1

Reproduction by Gateway Platemakers
Printed and bound in Great Britain
by BAS Printers Limited and Pitman Press

To my mother

With grateful thanks to my
brother Ian for his willing and
invaluable help throughout
the making of this book.

CONTENTS

GENERAL HINTS 105-113

TYPEFACES 114-128

ACKNOWLEDGEMENTS

The author would like to thank the following for permission to reproduce items of work commissioned by them : Mr. Peter Hurford ; York Minster ; University College, Durham ; The Royal College of Organists ; The Friends of Cathedral Music ; The Diocese of St. Albans ; The St. Albans Bach Choir ; Franklin Mint Ltd.

CALLIGRAPHY (PEN LETTERING)

The pen lettering of today is the direct descendent of the script used for book production before printing was invented. Nowadays, lettering by hand tends to be associated in the popular mind with important 'one-off' projects, such as books of remembrance and illuminated addresses; but it is still used in the commercial studio for book titles, maps, posters and the like: there is indeed a revival of interest in the commercial applications of pen lettering.

The calligrapher has many styles of letter from which to choose. Some are simple and easy to learn; others are more complex, difficult to learn and — be it admitted — sometimes even difficult to read. As the first priority in all writing should be legibility, the letters described in this book are all of the simplest variety.

Originally, goose or swan quills provided the calligrapher's pens—after cutting and shaping with a 'penknife'. These pens have to be constantly recut and, save for some very fine professional work, have been supplanted by metal nibs. But for those who want to try the 'feel' of the original quill pen, instructions on how to cut them are included.

Note to the left-handed:
If you are left-handed, you may find pen lettering rather difficult because you will have to hold the pen at an exaggerated angle to obtain the correct effect. You will find it helpful to use special oblique-angled nibs, and with patience a very satisfactory standard can be reached.

7

4	aA bB cC dD eE fF gG h Hi l j
3½	aA bB cC dD eE fF gG h Hi
3	aA bB cC dD eE fF gGh
2½	aA bB cC dD e Ef
2	aA bB cC dD e
1½	aA bB cC dD
1	aA bB c C
0	aA bB cC

8

EQUIPMENT

PEN-HOLDERS and PEN-NIBS can be obtained from most shops dealing in artists' materials. The special pen-holder has a tiny tongue of metal called the RESERVOIR which will store a small quantity of ink, releasing it gradually as you work. You can use ordinary pen-holders if you wish; for these, small detachable reservoirs are available.

Pen-nibs range from size 6 (the smallest) to size OO (the largest). The ones which will be most useful are shown in the illustration opposite, with the size of lettering obtainable from each. Pen-nibs 5 and 6 are very seldom required but they are normally included in the packs of assorted sizes, therefore it may be less expensive to buy nibs individually. Nibs can be oblique or straight. Most people find the straight ones easiest to use.

To make even larger letters than the OO nib can produce, the WITCH pen can be used. This consists of a pen-nib and reservoir all in one, and is ideal for notices and posters. Witch pens have their own numbering series, from size 1 (the smallest) to size 4 (the largest). A range of felt tip calligraphy pens is also available.

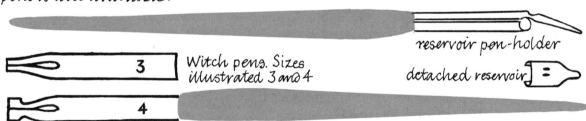

3 Witch pens. Sizes illustrated 3 and 4

reservoir pen-holder

detached reservoir

4

A DRAWING BOARD is essential. If you don't possess one, an old pastry board, or even a sheet of stout plywood, with a good, smooth surface will do. You must not work with the board horizontal — if you do, your pen may 'flood'. Rest the board at an angle — say about 30°. Fix your paper at a comfortable working position. As the work progresses, the paper's position will have to be readjusted.

Use a SMOOTH-SURFACED PAPER. As lines indicating the exact height of the letter must always be drawn, lined paper is a help when practising: choose paper with lines which are the same distance apart as the size of an 'a' in the pen you intend using — for example, lines 8mm ($\frac{5}{16}$") apart (a common size) suit pen 2. For final work a HOT-PRESSED paper is best. The smoothest side of the sheet should be used: a hot-pressed or hand-made paper may have a watermark which will read the right way round when viewed from the correct side.

INK of any kind, or watercolour mixed to the consistency of ink, can be used. The free-flowing fountain pen ink is excellent for practice. Always use a waterproof product for notices and posters. Black Indian ink, which is best for final work, is also waterproof. It is extremely black, which is perfect when the work has to be reproduced as it was in this book, but the pen-nib must be cleaned frequently as the ink dries quickly and clogs it up. Always

clean a nib thoroughly after use, but remember to dry it carefully if you wash it, otherwise it will rust.

FIXING THE PAPER TO THE BOARD

Pins may be used to attach the writing paper to the board but, as frequent readjustment is required to keep the line to be written at the correct level, the method described below is preferable.

To form a good working surface, the writing paper should rest on several layers of paper — newspapers will do. Arrange these on your board. Across them, pin a sheet of fairly strong, clean paper firmly to the board to hold all the paper securely. The upper edge of this paper should be just below what you consider to be the most comfortable writing position. The top section of the writing paper is held by a strong elastic band, or a tape, encircling the board horizontally. The writing paper can now be readjusted easily by pulling it upwards as each line for writing is required. The writing position is thus kept constant, and the holding paper protects the work.

SETTING THE NIB

Slip the nib into the pen-holder so that its tip is about 3mm ($\frac{1}{8}$") from the tip of the reservoir. The reservoir must JUST TOUCH the nib. If it presses too hard the split in the nib will be opened (hold it up to the light to check) and the reservoir will have to be eased off with the finger-nail. If contact is not made, remove the nib (or reservoir, if detachable) and adjust the reservoir until it just touches the nib.

3mm ($\frac{1}{8}$")

FILLING THE NIB WITH INK

The reservoir should be filled by using a brush, or the quill-shaped attachment often fixed in the stopper of proprietary ink bottles. Do not overfill the reservoir as this may cause flooding.

The nib can be filled directly by dipping it into the ink bottle but in this case the nib must be brushed against the neck of the bottle when withdrawing it to prevent overfilling the reservoir. Also, the upper surface of the nib must be wiped, if this method is used, as this part of the nib must always be kept clean and dry.

Always keep an ink bottle on the same side as your writing hand; never stretch over your work to refill your pen.

When writing final work it is advisable to 'try' a newly-filled nib EACH TIME on a scrap of paper pinned to the upper right-hand corner of your board to check for flooding.

GETTING STARTED

Hold the pen lightly and comfortably, with the flat end of the nib at an angle of 45° to the line. THIS ANGLE MUST NEVER VARY, whatever stroke you are doing. The whole of the flat end of the nib must touch the paper and only sufficient pressure should be exerted to enable the ink to flow freely; on no account should the split in the nib be pressed open. Your left hand should rest on the guard paper, near to your writing hand.

If the ink does not flow freely, the cause may be one or more of the following:

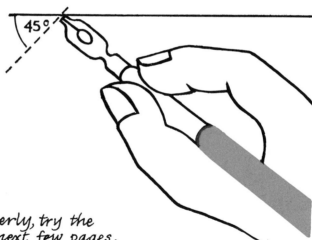

1. the tip of the nib may not be in full contact with the paper;

2. you may be holding the pen either too vertically or too near the angle of the paper surface;

3. the nib may be old and weak, causing the slit to open;

4. the ink may be too thick;

5. the nib may require cleaning;

6. if you are using a hot-pressed or hand made paper, see p. 67.

When your pen is working properly, try the practice strokes described on the next few pages.

First practise making a zig-zag pattern evenly and accurately. If the pen is being held at the correct angle, the up-stroke will produce the "hairline", which is the finest line possible, while the down-stroke will make the broadest line possible with the particular nib in use. You can always check if the pen is being held correctly by doing a piece of this pattern.

The next pattern is 'rope'. This is based on the zig-zag but with curved ends. The hairlines and the thick strokes are at exactly the same angles as before.

In many calligraphic letters the hairline is very important : it forms the link between letters when writing words. The hairline must NEVER BE ALLOWED TO BECOME THICK: if it does, the pen is not being held

innocent

at the correct angle of 45° to the line. Where there is no hairline (between 'o' and 'c' in the example above) an equivalent space must be left.

Now do the following pattern which includes a vertical stroke.

If the pen is held at the correct angle, the width of the vertical stroke is about two-thirds that of a broad stroke. The top part has a sharp point.

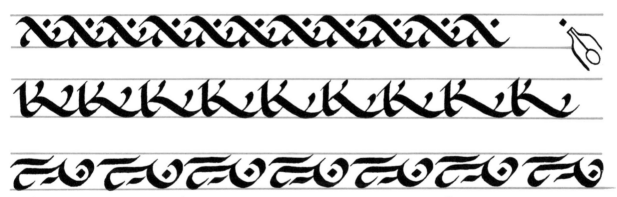

You should now be able to invent your own patterns. Keep the pattern neat, touching both top and bottom lines. This kind of decoration will be found useful later on, when designs may be required to fill spaces left at the end of text lines. The diamond shaped dots are just tiny sections of a broad diagonal.

Having mastered these, you can move on to your first letters.

ROUND HAND LETTERS

These simple letters are rather grandly called the FOUNDATIONAL ROUND
HAND – 'Round Hand' for short. They are a little more difficult than italic
letters, but, once mastered, any other style of letter is easily learned as the
letter-shapes and method of forming them are basically the same. The
'lower case' letters (small ones) have been written beside the 'upper case'
letters (capitals) as there can often be confusion with proportions. All
the illustrations on the following pages are shown actual size for nib 2
unless stated otherwise, i.e. the height of a small letter 'a' is 4½ times
the width of the nib.

aA bB cC dDe EfF gG
hHiIjJkKlLmMnN
oOpPqQrRsStTuU
vVwWxXyYzZ;:?()₂

FORMING ROUND HAND LOWER CASE LETTERS

The high letters (those with ascenders) of the Lower Case (L.C.) and those with tails (descenders) are JUST UNDER TWICE THE HEIGHT of a small letter 'a' (the 'x' height). The decorative beginning of many of the letters is called a 'serif,' and a description of how these are formed will be found on the next page. If you can, try to perfect each stage before going on to the next: one or two lines filled with each shape or letter should make you thoroughly familiar with it. In each illustration the fully-formed letter or shape is given first, followed by the consecutive strokes required to make it. Pitfalls to be avoided are also shown when necessary.

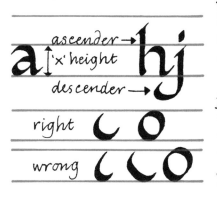

The 'o' is the simplest letter and is best practised first. It is made up of two strokes and it should be as round as possible. Begin by making a half-moon shape lying on its back, starting the hairline just below the top line. Stroke 2 slightly overlaps the first hairline before curving up to touch the line and then down to join the other hairline near the base.

As the letters 'c' and 'e' are formed of basically similar strokes to those of the 'o', they are described next.

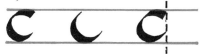

The 'c' begins like the letter 'o'. The second stroke is also similar, but stops short when the pen arrives at a position above the base hairline.

17

Stroke 1 of 'e' is the basic curve already described. Stroke 2 extends until above the base hairline, before curving inwards to join the thickest part of stroke 1 as a hairline.

The first stroke of the 'a' begins with a large curve, followed by a vertical, and ends in a tight curve and a hairline. Stroke 2 begins halfway between the lines and curves outwards to the limit of the hairline above. Stroke 3 begins on the hairline of 2, and, with a shallow curve, DISAPPEARS ENTIRELY into the vertical.

Before you go much further, you need to learn the serif. It is rather complicated but comes into many letters. The simplest case is the letter 'i'. The serif is formed by two very precisely shaped strokes. Practise the 'i'.

serif

Begin stroke 1 at the line. Bring the pen down to form a hairline, then, without lifting the pen from the paper, move the pen up and round in a tight curve. IMMEDIATELY THIS STROKE BECOMES VERTICAL LIFT THE PEN; IT MUST BE A VERY SHORT STROKE. Stroke 2 begins as a hairline, a little above – but in line with – the hairline of 1, then curves downwards as a vertical, exactly covering the short vertical of 1; it finally ends with the usual curve and hairline.

wrong

18

wrong

N.B. If stroke 1 of the serif is inaccurate, the mistakes illustrated can occur: a bend in stroke 2 or a space within the serif.

Lower case letters with ascenders are just under double the height of small ones. Stroke 1 of the 'b' therefore, begins as a serif just below the upper line limit: its vertical continues into the second space, ending in a large curve. Stroke 2 is similar to that of the 'o'.

Begin the 'd' like the 'c'. Stroke 2 is a shallower curve than that of the 'c' but is similar in length. Stroke 3: the left point of the serif hairline ends directly above the centre of strokes 1 and 2, enabling the main vertical to join them before ending in the usual way.

Now you know sufficient letters to try some words. Join each letter with the hairline, if present. Where there is no hairline, its approximate width must be left blank. Write each word several times.

ace dab bade bead

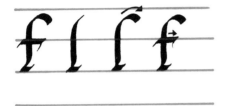

Begin stroke 1 as a curving hairline almost halfway down the upper space; it continues vertically, curving off to the left with a hairline just before reaching the baseline. Without lifting the pen, make a SHORT, STRAIGHT, horizontal base, taking care the hairline remains visible. The crossbar is a horizontal, slightly longer to the right of the letter, and begun and ended with tiny hairlines.

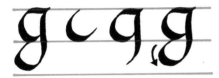

Stroke 1 is similar to that of the 'o'. Stroke 2 ends horizontally with a TINY upturned hairline from which the stroke reverses to change to the vertical which ends as a curved hairline halfway down the space. Stroke 3 completes the tail, which begins by touching stroke 1 at the line.

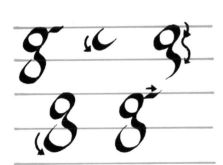

There is an alternative 'g' which is more difficult. Stroke 1 curves off midway between the lines. Stroke 2 completes the opposite curve but continues to form an 's' shaped tail. The final tail stroke begins by touching the second curve of stroke 2. Stroke 4 is a short version of the 'f' crossbar, beginning from the upper curve of stroke 2 and rising to touch the line.

h l h

i i ←wrong j

k l k k

l

Stroke 1 of 'h': there is NO hairline at the base of this. Stroke 2 begins a little below the upper line and curves upwards to touch it before descending vertically to end as usual on the baseline.

The 'i' has been practised already. The dot is just a section of a vertical stroke, placed DIRECTLY IN LINE WITH, and close to, the letter. The 'j' is similar to an 'i', with the tail of a 'g'.

Stroke 1 of 'k' as in 'h'. Stroke 2 is formed by a tiny down-curve from the line, which STRAIGHTENS immediately to join stroke 1 midway between the lines. Stroke 3 is STRAIGHT until it ends with the usual curve and hairline.

The 'l' is similar to stroke 1 of the 'k' but ends on the baseline with a curve and a hairline.

Now you know most of the basic strokes involved in forming letters: from this stage onwards therefore, comments will only be made when something new appears.

hedge cage jab liked

m i n̂ m

n i n o

p j p̂ p

q c c q

r i r̂ r

s ŝ s̑ s̩

There are no hairline endings on strokes 1 and 2 of the 'm'. Strokes 2 and 3 have full, round tops. The main sections of all three strokes are VERTICAL.

The 'n' is formed by strokes 1 and 3 of the 'm'. You have already learned the 'o'.

In 'p' stroke 1 ends as a hairline curving to the left, finishing just above the tail baseline. Stroke 2 is as in the 'o'. Stroke 3 is a short curve, beginning on top of stroke 1 and joining stroke 2.

Strokes 1 and 2 and the main part of 3 are similar to the 'g'. End off stroke 3 by a curve and hairline just before reaching the baseline.

Stroke 1 of 'r' has no base hairline. Stroke 2 must begin as a hairline touching stroke 1 which rises up to the line where it may travel either horizontally or downwards, ending each time in a tiny hairline.

The 's' is the most difficult to do. Begin just below the upper line, curving immediately to cross at an angle before ending in the opposite direction, just above the baseline. The centre section of this stroke is straight. Strokes 2 and 3 are shallow curves, 2 ending

22

when in line with, and 3 beginning just beyond, the outer curves of stroke 1.

Stroke 1 of 't' begins like a serif, but instead of curving to a vertical, it continues horizontally on the line, ending with a hairline. Stroke 2 begins just above 1 as in a serif, and continues vertically to end as usual on the baseline.

Stroke 1 of the 'u' has a richly curved base. Its hairline is then caught by stroke 2.

In 'v' stroke 1 must be completely straight following the first curve, and ends abruptly as it touches the line. Stroke 2 is again straight after the first curve, and joins stroke 1 as a fine, straight hairline, forming a point.

The 'w' is similar to the 'v' but with the first stroke repeated. Strokes 1 and 2 are joined by a straight hairline, beginning from the base of 1.

Stroke 1 of the 'x' is similar to that of the 'rope' pattern. Stroke 2 begins with a curve on the base-line, moving diagonally upwards as a hairline, to end in another tiny curve.

The 'y' is similar to the 'v' but stroke 2 continues into a hairline ending just below the line. Stroke 3 begins above this line, and beneath the curve of 1; it curves outwards and then up to join the hairline of stroke 2. Do not make the tail too long.

The 'z' is a one-stroke letter, beginning and ending with a very short hairline. The letter should be within a square, except for the tail which may extend a little beyond the upper stroke limit.

The QUERY is the same height as a tall lower case letter. Stroke 1 begins as a rich curve, descending to a hairline which, once over the line, changes to a vertical and ends midway between the lines. The dot lies on the line, immediately beneath.

INVERTED COMMAS are at the height of a normal high letter. The HYPHEN is placed midway in the space. Remember to place punctuation marks CLOSE TO the preceding word.

wrong

Why? :,;"Help!"x-ray.

24

1234567890

1234567890

Numerals may be the same height or may vary, with some above and some below the lines, depending on the particular numeral.

Now you have learned how to form all the lower case letters of the alphabet, writing proper can begin. The sentence below uses all the letters. The rules applying to letter spacing are the same as those for drawn lettering – see p. 99. The width of a lower case 'o' should be left between words.

the quick brown fox jumps over the lazy dog

FORMING ROUND HAND CAPITAL (UPPER CASE) LETTERS

The capitals (caps) suitable for use with the lower case letters, and already illustrated on p. 16, will now be described in detail. N.B. THEY ARE VERY SLIGHTLY SHORTER THAN HIGH LOWER CASE LETTERS such as 'l' or 'h'.

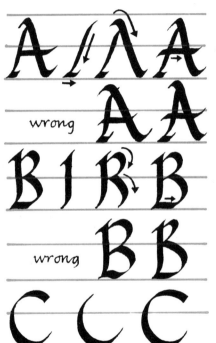

wrong

wrong

Stroke 1 of 'A' begins as a hairline and descends as a straight line; it is similar to stroke 1 of a lower case 'f' but lies at an angle. The tiny STRAIGHT base serif is used with these capitals. Stroke 2 curves over and touches stroke 1 before descending in a straight line in the opposite direction to 1, curving off as it reaches the baseline. The crossbar can either lie between 1 and 2, or cross them.

Stroke 1 of the 'B' is vertical and ends as a hairline on the baseline. Stroke 2 curves round and extends a little over the centre line. Stroke 3 begins on the final hairline of 2 and forms, at first, a shallow curve before turning towards the baseline to end just above it. The final stroke is STRAIGHT until it curves to join stroke 3.

The capital 'C' is similar in construction to the lower case 'c'.

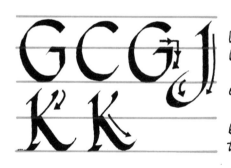

Stroke 1 of the 'D' is similar to that of the 'B', and as it occurs in many letters it will no longer be described. Stroke 2 is a large curve ending just above the baseline. Stroke 3 is a larger version of the base of the 'B'.

Stroke 1 of 'E' as in 'B', but without lifting the pen, continue it to form the horizontal base. Stroke 2 rises to lie level with the serif top. Stroke 3 lies on the middle line. The centre stroke is the shortest, the base the longest.

'F' is similar to 'E' but with a short base serif on stroke 1. 'H', 'I' and 'L' are all formed by various combinations of the 'E' and 'F' strokes.

For 'G' proceed as for 'C'. Stroke 3 is begun on the centre line, changes to the vertical, then curves to join the hairline of stroke 1.
'J' has a tail similar to the lower case 'j', lying either on or below the line.

Strokes 2 and 3 of 'K' are similar to the lower case 'k' but are, of course, larger, stroke 2 beginning level with the top of the serif. It descends to cut the middle line.

27

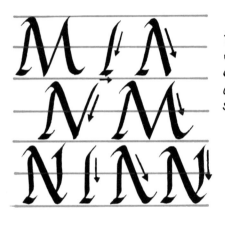

'M' is the most difficult letter to do. Stroke 1 is similar to that of the 'A', but is closer to the vertical. Stroke 2 ends abruptly on the baseline, and is at a greater angle than stroke 1. Stroke 3 is at the opposite angle to 2. Stroke 4 coincides with the hairline of stroke 3 before descending at the opposite angle to 1.

The outer strokes of the 'N' are VERTICALS. Stroke 2 is like the second stroke of the 'A' but lies at a greater angle. Stroke 3 descends to join the lower part of 2 in a hairline.

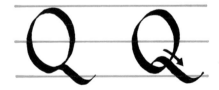

The 'O' is similar to the lower case 'o'. See letter 'Q'.

Stroke 2 of the 'P' is richer and rounder than that of the 'B', its hairline extending below the centre line at a distance from 1. Stroke 3 joins strokes 1 and 2.

The 'Q' is an 'O' with the addition of a single stroke tail which may either join the main letter at the hairline, or cut through the hairline completely. The middle section of the tail is straight.

28

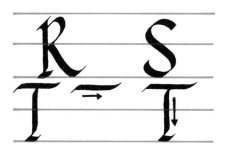

The curved top of the 'R' is similar to that of the 'B'. Stroke 3 is similar to the tail of 'K'. 'S' is similar in construction to the lower case 's'.

The crossbar of the 'T' is a horizontal line beginning and ending with a small hairline. It crosses the hairline of the vertical.

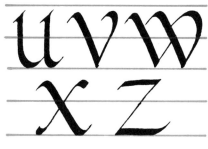

The 'U', 'V', 'W', 'X' and 'Z' are similar to their lower case counterparts.

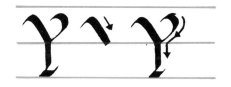

The 'Y' is begun like the lower case 'v' but is drawn in the upper space at the correct height. On joining stroke 1, stroke 2 becomes vertical, ending as usual on the baseline.

29

CHOOSING THE PEN SIZE

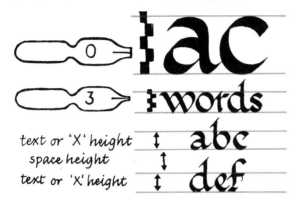

text or 'X' height

space height

text or 'X' height

In a round hand letter, the height of a lower case 'a' should be about 4½ times the width of the nib. Therefore, the pen size is determined by the height of letter you require.

Space height is generally equal to, or slightly greater than, text height.

MEASURING

When you have decided your pen size, make yourself a scale by marking the text height and the space height you wish to use on the edge of a piece of paper. Use this simple paper scale throughout the work — it will be more accurate than using a ruler. Mark each text space with a bracket — this ensures that you will not write accidentally within the space height.

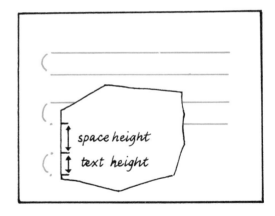

space height

text height

RULING UP

The simplest method of ruling parallel lines for lettering is with a T-SQUARE. This is an accurate wooden or steel rule shaped like a 'T' and having a perfect right angle. It must be used in conjunction with a drawing board, the bevelled edge being used to draw the lines. A T-square saves much of the repetitive measuring necessary with an ordinary ruler.

Fasten the paper to the drawing board with its edges parallel to those of the board. Ensure the 'head' of the T-square is flush with the edge of the drawing board. Using the T-square vertically at first, draw two vertical lines to indicate the approximate limits within which you intend to work. Down the first line mark the text and space heights using the measurements on the paper scale you already prepared. Then, turning the T-square to the horizontal position, draw lines EXACTLY through the points. ACCURACY IS VERY IMPORTANT. Do not press too hard as the pencil lines must be erased later.

PLANNING A PIECE OF LETTERING

Always plan lettering carefully. Aim at arranging the words into a 'block' shape which will allow clean, neat margins around it. The easiest way to plan a piece of prose is to write out the passage several times in ordinary handwriting, ending the first line at various places, and incorporating any enlarged capitals that may be required. Choose the scheme where most lines end at, or near, the length of the first line. By doing this the final 'shape' of the passage will be seen. Avoid hyphens. Below are several 'tries' of the same passage.

1. A thing of beauty is a joy for ever; its loveliness increases. It will never pass into nothingness.

2. A thing of beauty is a joy forever; its loveliness increases. It will never pass into nothingness.

3. A thing of beauty is a joy for ever; its loveliness increases. It will never pass into nothingness.

'1' and '3' are both possible as a first letter can be within or outside the text. In '2' the space beneath 'A' would allow for decoration if required.

A thing of beauty is a joy
for ever; its loveliness
increases. It will never
pass into nothingness.

A thing of beauty is a joy for
ever: its loveliness increases. It
will never pass into nothingness.

nib 3

THE FINAL LETTERING

Before tackling the final example, write out in pen lettering at least one ACCURATE ROUGH. By doing this, you will discover any collisions which may occur between the 'tops' (ascenders) and the 'tails' (descenders) of letters, or where an alteration in the word spacing might help. You may find it useful to pencil in the lettering lightly for both the rough and the final before inking it in, as this can prevent letters being missed out during the concentration of writing. Ensure though that the pencil shapes are in proportion to the final pen letters. When the rough is complete, it will be simple to decide where to place the text on the final sheet to allow for well balanced margins.

Unless the space between lines is fairly wide, there will be collisions between the tails (descenders) of one line and the tops (ascenders) of the next line. To make these as attractive as possible, the shapes of both tops and tails can be altered somewhat, or the spacing between words slightly modified, or both. It helps in arriving at the best compromise if you leave out the tails in each line you write until after the following line has been written. Some attractive, contrived collisions are shown here.

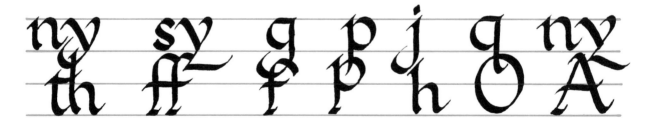

34

EXTENDING AND CONDENSING LINES

A line can be extended by enlarging the spaces between words. Similarly, spaces can be narrowed to give the opposite effect, but such alterations should be minimal and not obvious in the final work. Other alternatives helpful in condensing a line are the crossing of round letters and the substitution of the ampersand (&) for the word 'and'. The ampersand should be used only with discretion. Capitals can occasionally slip within or above another capital or lower case letter to take up less space.

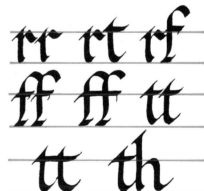

SOME USEFUL TIPS

The downward curving version of the two 'r's already described is the most suitable shape to combine with a following 'r', 't' or 'f'.

When two 'f's or 't's come together, either shorten the cross strokes or cross both letters with one continuous stroke.

When a 't' lies immediately before an 'h' place the serif of the 'h' in line with that of the 't'. This should give the correct spacing.

Capitals can be used to emphasise certain words, phrases or complete passages, and this is especially useful when colour cannot be used. When writing a series of capitals, you will need to draw an extra pencil guide-line to indicate their height.

Thirty days hath SEPTEMBER,
 APRIL, JUNE and NOVEMBER.
All the rest have thirty-one,
 Excepting FEBRUARY alone,
Which has twenty-eight days clear,
 And twenty-nine in each Leap Year.

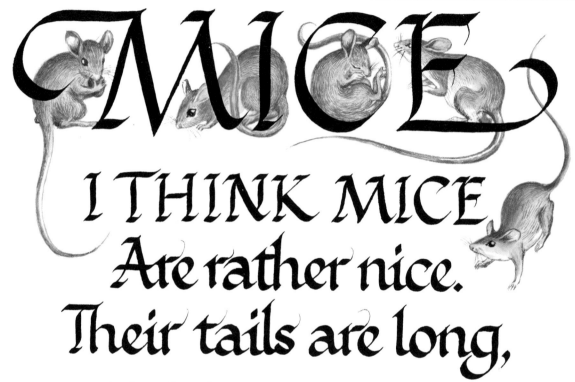

MICE

I THINK MICE
Are rather nice.
Their tails are long,

detail from 'Mice' by Rose Fyleman. Full poem on p.53.

ENLARGED CAPITALS

Enlarged capitals are found in titles, or at the beginning of paragraphs or lines of poetry. They can take the form of simple, enlarged versions of the standard capital, or can be decorated with additional lines or flourishes. Provided THE BASIC SHAPE IS MAINTAINED, and the letter remains clearly visible, you can be freely imaginative. Some ideas for decorative letters are given on the following pages.

In framing artists,
art has thus decreed,
To make some good,
but others to exceed.

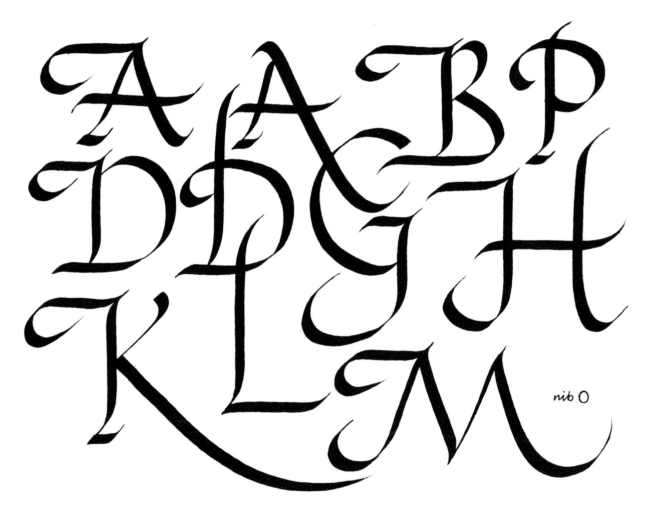

nib 0

39

W P T H
R V V F
B G Y Y Z

nib 1½

40

ABCDEFG
HIJKLMN
OPQRSTU
VWXYZ

The fine lines are added with an ordinary pen-nib.

nib 1½

41

TITLES

Titles are best written AFTER the main writing has been completed. The placing of the title is very important. It can be written using either (a) the same size of nib as that used for the main writing, in lower case or capitals or (b) a larger nib size, in lower case or capitals.

Try out several styles and sizes on strips of paper which can then be placed above the finished lettering. Move the chosen one around until the best position is reached, KEEPING IT CLOSE TO THE TEXT. Then, either mark its position carefully or actually transfer it through (see p.105) before drawing the guidelines and inking it in.

AUTHORS' NAMES AND REFERENCES

These are treated in the same way but are written in a smaller size of letter (and hence nib) than the main text. They can come beneath the title (in which case the two should be worked out at the same time), at the end of the work, beneath the text, or even at the end of a final line if there is sufficient space. In any alternative keep the name(s) close to the text. Examples can be seen on p.52 and on the frontispiece.

Some examples of titles follow. They are actual size for the nib sizes stated.

MEASURE FOR MEASURE

nib 2½

42

Venus & Adonis *nib 2*

THE TEMPEST *nib 2*

KING LEAR *nib 1½*

The Winter's Tale *nib 2*

43

THE USE OF COLOURED LETTERS

A simple method of decoration is by the introduction of coloured letters in the title or at the beginning of lines. Three suggestions for the use of colour are shown below, the blocks of colour indicating coloured titles and capitals.

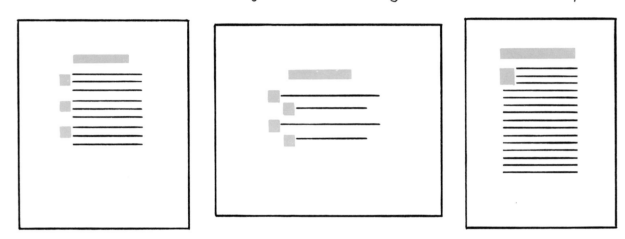

Coloured inks can be used for pen lettering but the range of colours available is limited. If you wish to use a more subtle colour, WATERCOLOUR (NOT POSTER COLOUR) mixed to the consistency of ink is a good substitute. Use a brush to feed the reservoir but take care not to overfill it. Stir the paint each time you fill the pen as the grains of colour tend to sink.

ILLUMINATION

Painted decoration, known as illumination, is as important as the lettering when used. It should therefore be very fine and accurate. Decoration should be added with reserve, unless you are very experienced; it should never dominate the lettering or affect its legibility. To be 'safe', arrange your design to echo the shape it surrounds. It is more difficult to achieve a balanced page if the design is less organised.

Decoration can echo the subject matter, as in the poem on pp. 37 and 53, or can be based on plant, geometric or abstract forms, or be simply pen patterns. The eighth-century 'Book of Kells' has splendid examples of geometrical designs.

Plant form is perhaps the simplest. An easy way to design such a border is to draw a wavy 'skeleton' within the border shape, to which can be added, in succession, further stems, leaves and flowers, Stars, dots and suchlike may be added as, being a design, it need not be realistic, any more than the colour. Choose your colour scheme carefully. Shades of one or two colours in a design can be more subtle and pleasing than many completely different colours.

Illustrations from ancient illuminated manuscripts will provide you with design ideas and colour schemes.

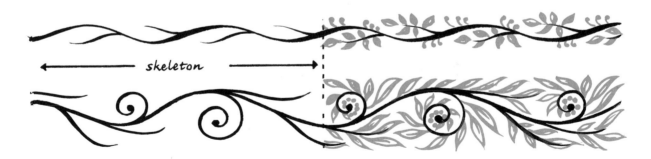

skeleton

ILLUMINATED CAPITALS

These are generally enlarged calligraphic letters, but drawn. Roman letters (see pp. 74, 75) are permissible as they are similar to the VERSAL letters of the mediaeval calligrapher. The versal letters are not described in this book, but examples can be seen in the illustration on p. 52.

Illuminated capitals should be indicated in pencil before doing the calligraphy. Final drawing and painting should be completed afterwards. Note: a very large calligraphic capital is a drawn and painted facsimile — the pen is not used to form it.

Gold leaf provides a particularly rich form of illumination. The process is, however, difficult, and those interested should consult specialised publications.

NOTICES AND POSTERS

Always write out all the information FULL SIZE in pencil on the final sheet BEFORE DRAWING ANY GUIDE LINES. The size of the lettering which will fit into a given space can then be estimated.

The NAME OF THE EVENT, the DATE and PLACE are generally the most important details, and these should be emphasised.

Various ways of emphasising words or phrases may be used to increase the visual interest of a notice, for example:

1. using a variety of sizes
2. incorporating upper and lower case letters
3. coloured letters
4. colour in the background.

For any one pen size, more lower case letters can be fitted into a given space than capitals. Mixed capitals and lower case letters also 'read' more easily from a distance.

The larger sizes of nib available as witch pens are very easy to use, once the smaller sizes have been mastered. You will soon become confident with a little practice.

Always use WATERPROOF products for writing notices and posters unless they are to be displayed indoors.

The illustrations opposite show four ways of introducing an additional colour to the same piece of lettering.

48

The Art Society
is holding an
EXHIBITION
at the Town Hall
MARCH 7-26
Daily 10am-6pm

The Art Society
is holding an
EXHIBITION
at the Town Hall
MARCH 7-26
Daily 10am-6pm

The Art Society
is holding an
EXHIBITION
at the Town Hall
MARCH 7-26
Daily 10am-6pm

The Art Society
is holding an
EXHIBITION
at the Town Hall
MARCH 7-26
Daily 10am-6pm

ALTERNATIVE ROUND HAND LETTERS

These letters have simple, rounded serifs.

aAbBcCdDeEfF

gGhHiIjJkKlLmM

nNoOpPqQrRsStT

uUvVwWxXyYzZ.

These letters are even more simplified, with no serifs. Note the alternative versions of the lower case 'a' and 'd' and the capital 'E'.

aaAbBcCddDeEFf

gGhHilijJkKlLmM

nNoOpPqQrRsStT

uUvVwWxXyYzZ

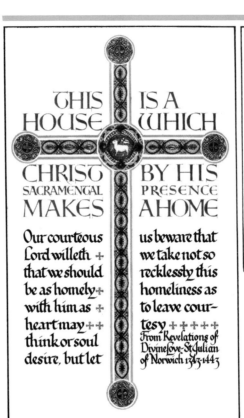

THIS HOUSE IS A WHICH
CHRIST BY HIS
SACRAMENTAL PRESENCE
MAKES A HOME

Our courteous Lord willeth + that we should be as homely+ with him as + heart may++ think or soul desire, but let us beware that we take not so recklessly this homeliness as to leave cour- tesy +++++ From Revelations of Divine Love - St Julian of Norwich 1343-1443

Our courteous Lord willeth + that we should be as homely+ with him as + heart may++ think or soul desire, but let

us beware that we take not so recklessly this homeliness as to leave cour- tesy +++++ From Revelations of Divine Love - St Julian of Norwich 1343-1443

The prayer illustrated on this page is written in round hand calligraphy combined with versals, a mediaeval style of letter not described in this book but found in many other lettering manuals. The detail printed above shows how the name of the authoress has been incorporated in the design. OPPOSITE. Two further examples of round hand lettering. The organ record sleeve uses very simple, quickly formed pen letters.

52

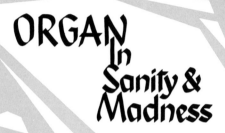

ORGAN
In Sanity & Madness

A recording
of part of the
concert devised
by Peter Hurford
for the Royal
College of Organists'
Centenary Appeal
and given at the
Royal Albert Hall, London,
on September 24th·1966

MICE

I THINK MICE
Are rather nice.
Their tails are long,
 Their faces small,
They haven't any
 Chins at all.
Their ears are pink,
 Their teeth are white,
They run about
 The house at night.
They nibble things
 They shouldn't touch,
And no-one seems
 To like them much.
But I think mice
 Are nice.

ITALIC PEN LETTERING

Italic letters SLOPE SLIGHTLY from the vertical and are NARROWER than those of the Foundational Round Hand. Foundational letters can therefore be converted to the italic form given on p.63 by simply applying these two modifications. Further modifications are possible, however, for in the examples below the serifs have been simplified and the letters made more sharply pointed. Note that in this version the proportions of ascenders, descenders and capitals to the 'x' height are similar to those of the Foundational Round Hand, but in other italic versions they may double the 'x' height or may even be a little longer in a more decorative script. The nib size also may be narrower in relation to the 'x' height than used in the Foundational Round Hand (see p.64).

abcdefghijklmnopqrst

uvwxyz,1234567890(?!).

A B C D E F G or G H I J

K L M N O P Q R S T or

T U V W X Y or Y or Y Z

 A FULL-STOP, *actual size, followed by an enlarged diagram of its structure.* The COMMA *is a full-stop with a tail.*

BASIC STROKES

These strokes should be learned first. There is no definite rule about the degree of slope but just a little off vertical should be enough. Consistency, however, MUST be observed.

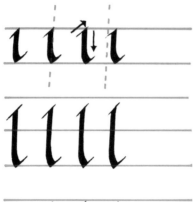

This first stroke shows the characteristic 'pointedness' of the italic letter. The hairline serif extends just above the line. DO NOT LIFT your pen but go back down the serif a little before descending with a straight stroke. This curves just before it reaches the baseline, and ends in a point and a hairline.

This is a larger version of the first stroke, and is used in most high letters. It is completely straight until the base curve and pointed ending.

This shallow curve is the basic stroke of many letters. It has the same sharply pointed base.

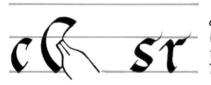

This 'flourish' MAY be added to the curved tops of the 'c', 'r' and 's', and the crossbars of 'f' and 't'. It is formed at the end of the final stroke by turning the nib, so that only one tip touches the letter. This lip then pulls down, or up, a fine line of ink.

56

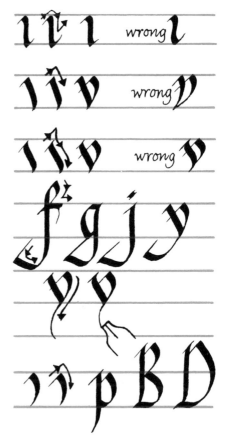

This shape is found in the 'h', 'u' and 'm'. There is a curve immediately after and before each hairline; the centre part is straight.

This shape begins the 'v', 'w' and 'y'. It is similar in form to the round hand shape for the same letters except that it is pointed at the top, and there is a SLIGHT curve as it descends to the baseline.

The second shape used for 'v', 'w' and 'y' in the alternative letters shown on p. 62 is similar but for the tiny curve in the OPPOSITE direction beneath the serif.

The FINAL stroke of the tails of 'f', 'g', 'j' and 'y' begins as a hairline on the lower text line, close to the body of the letter. It continues well into the lower text space, before abruptly reversing.

The second 'y' tail is found in the alternative letters on p. 62. It is formed in the same way as the 'flourish' (see opposite).

This shape is found in both lower case letters and capitals. It begins as a hairline which extends to the upper limit of the letter before turning sharply to descend as a gentle curve.

57

No further descriptions of the formation of letters will be given as they closely follow the structural rules which apply to round hand letters. Consecutive stages, with dots marking where sharp points occur, will be shown.

ɪca lb ɪc ɪcd ɪe ʃʃʃ

ɪcgg lh i jj ltk inm

in co ʃpp ɪcq ir ʃss t

tu ɪv inw ix ɪyyy z

ᴀ A ᴊᴘʀʙ ᴄᴄ ᴊᴅᴅ

ʟᴄᴇ ᴊ ᴊꜰ ᴄᴄ G or GG ᴊ ʜ

ᴊ ᴊ ᴊ ᴊ ᴘ ᴋ L ᴊ ᴀ ᴀ M

ᴊ ᴀ ᴀ ᴄᴏ ᴊ ᴘᴘ Q ᴊ ᴘ ʀ

59

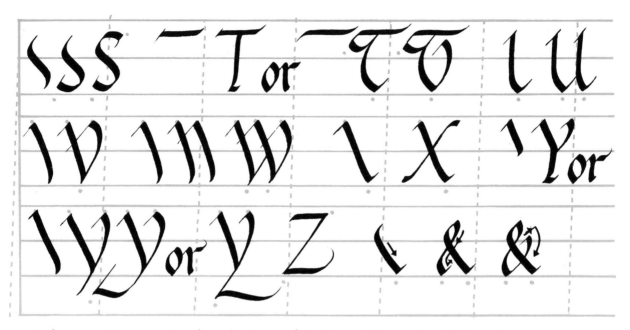

ƧƧƧ ⌐ T or ℧℧ lU

lV llW l X 'Y or

lyy or y Z & & &

When writing out a final piece of italic calligraphy, it is wise to draw out guide lines indicating the degree of slope. To do this, mark points 25mm (1") apart across the top of the writing area. Do the same along the baseline, but begin these similarly spaced points a small distance to the left of the ones above. Join up the points lightly in pencil.

aAbBcCdDeEfFgG

hHiIjJkKlLmM

nNoOpPqQrRsStT

uUvVwWxXyYzZ

aA bB cC dD eEf F gG

hH Iilj J kK lL mM

nN oO pP q QrR sS tT

uU vV wW xX yY zZ

62

aA bB cC dD eE fF gG

hH iI iI jJ kK lL mM

nN oO pP qQ rR sS tT

uU vV wW xX yY zZ

63

DECORATIVE ITALIC CALLIGRAPHY

The flourishes used to decorate italic pen lettering change direction sharply
rather than with a curve as in round hand calligraphy; compare with p. 39.

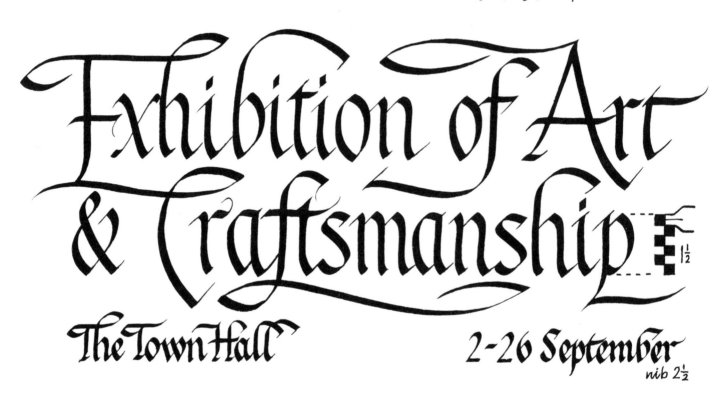

Exhibition of Art
& Craftsmanship 1½

The Town Hall 2-26 September
nib 2½

ON THE REED

I was of late a barren plant
Useless, insignificant,
Nor fig, nor grape, nor apple bore,
A native of the marshy shore;
But gather'd for poetic use
And plunged into a sable juice,
Of which my modicum I sip,
With a narrow mouth and slender lip,
At once, although by nature dumb,
All eloquent I have become,
And speak with fluency untired,
As if by Phoebus' self inspired.

A final piece of calligraphy should appear 'even'. Slight variations in the width of text lines, or the angle of the upright strokes of letters, can spoil the whole effect.

Italic letters are more compressed and speedier to write than round hand letters and are ideally suited to poster work. The lettering below compares italic with round hand in the space available. A size 3 witch pen was used for both examples.

BARBECUE

BARBEC

REMOVING MISTAKES IN CALLIGRAPHY

Provided you have used a 'hot-pressed' lettering paper, mistakes can generally be removed by using a FINE INK eraser.

Make certain the ink has dried thoroughly before attempting to rub out. Rub the spot gently but persistently with the eraser until all traces of ink have been removed. Smooth down the area with the back of your fingernail before lightly pencilling in the correction and rewriting. Very small errors can be scraped away with a scalpel or a sharp knife.

If the paper is too weak to stand erasing, a mistake can be painted out, but this will be slightly visible whatever you do, and it will not stand retouching by pen. If paint is used to 'touch out' on white paper, it must be toned to match the paper, as whites vary greatly. In time, it is likely that the paper and the paint will fade differently, making the correction rather more obvious.

INK FLOW ON HOT-PRESSED PAPER

Very occasionally, ink fails to flow freely over the paper which may be too smooth, or slightly greasy. Sometimes the ink itself can be at fault: try another make. If still in difficulty, you can try two remedies, either add a minute trace of liquid detergent (washing-up liquid) to the ink or paint, to break the surface tension, or GENTLY rub the paper surface with some scouring powder and a soft cloth. Remove ALL traces of the powder before attempting to write.

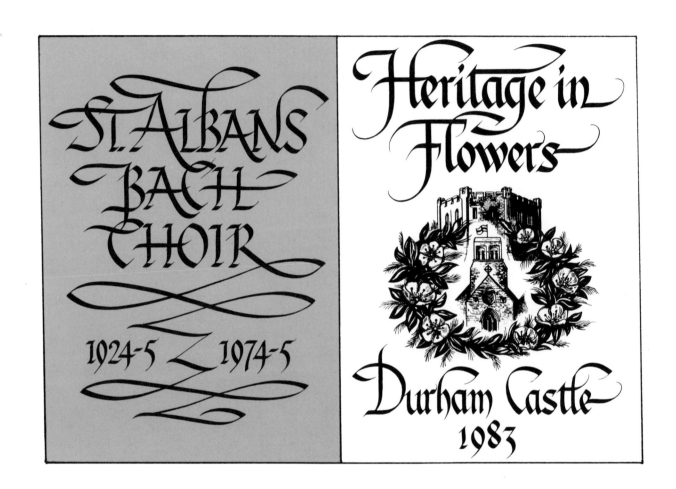

St. Albans Bach Choir

1924-5 1974-5

Heritage in Flowers

Durham Castle
1983

17th Century Nun's Prayer

Lord Thou knowest better than I know myself that I am growing older and will someday be old. Keep me from the fatal habit of thinking I must say something on every subject and on every occasion. Release me from craving to straighten out everybody's affairs. Make me thoughtful but not moody; helpful but not bossy. With my vast store of wisdom it seems a pity not to use it all, but Thou knowest Lord that I want a few friends at the end.

HOW TO CUT A QUILL

Goose quills are excellent: a poulterer can usually supply these for a few pence.

You will require: a very sharp knife, a small piece of smooth metal, a thin pointed instrument such as the handle of a fine paint brush or knitting needle, and a tiny piece of thin, springy metal.

1. Strip the feather quill. It may look decorative but can get in the way when writing. Trim off the thin end if necessary leaving 200-250 mm (8"-10").

2. Cleanly cut off approximately 10mm (½") from the growth tip.

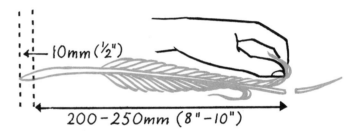

10mm (½")

200-250mm (8"-10")

3. Clean out the inside of the quill and scrape away any roughness from the outside.

4. Make a fine cut approximately 3mm (⅛") long in the pen-end of the quill. Lengthen this cut to about 10mm (½") by inserting the pointed instrument and pressing GENTLY against the cut. If the left thumbnail is pressed firmly on the quill at the required distance, this will prevent the slit extending too far.

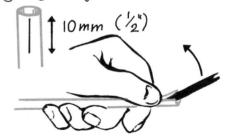

10mm (½")

5. Hold the slit-end towards you with the slit at the bottom. Cut a diagonal slice off the upper part, not more than 20mm ($^4/_5$") long (a), leaving the part with the slit (b).

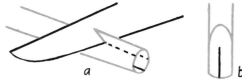

6. Still holding the open end towards you, cut the two sides to produce a nib of approximately the desired width: make certain the slit is in the middle of the nib.

7. Lay the end, inner face down, on the metal. Make a clean, slanting cut across the tip of the nib, at right angles to the slit, at the part of the nib which will give the required final width.

cut

8. To make the reservoir, cut a tiny strip of metal 3 mm × 40 –50mm ($^1/_8$" × 2"). Bend the metal as illustrated to form a spring. Slip this into the end of the quill, so that the tip of the reservoir touches the pen 3mm ($^1/_8$") from the quill top. The loop 'a - b' holds the ink. It should be a shallow curve; a deep curve would hold an excess of ink which may result in flooding.

3 mm ($^1/_8$")

a b

Because of the limited size of quills readily obtainable, they are only really practicable for small nib sizes — say up to 2½ maximum. For these small sizes they are capable of very fine, sharp work, but they tend to lose their sharpness quickly and need frequent re-cutting.

DRAWN LETTERING

All our common styles of letter derive from the Roman alphabet. Countless variations exist, and new ones are being introduced: witness the variety of typefaces used by the press, book publishing and advertising. The typefaces used by the printing trade are classified according to their origin and general characteristics. Many designs are based on types of the past or are contemporary versions of them. Every typeface is known by a name, often that of its creator, such as Gill, Bodoni and Baskerville. Each typeface includes punctuation and numerals, and most are available in 'italic', 'extended', 'condensed', 'light' and 'bold' versions. Examples of well known typefaces are shown at the end of this book.

 Some typefaces, such as 'Gallia' or 'Caslon' have serifs, others – 'Eurostyle' or 'Futura' – do not, and are known as 'sans serif'. The true Roman serif has a gentle 's' shape and is sharply pointed. A simplified serif, more commonly used, straightens out this curve and can either be sharply pointed or thickened with squared edges. When the serif curve is at right angles, or acute, the correct curve can be estimated by sketching in a tiny circle, to be removed later.

I C I C I C I C

Roman Serif Simple Serif Square Serif Sans Serif

72

ABCDEFGHIJKLMNOPQRSTUV

Gill Sans

ABCDEFGHIJKLMNOPQRSTUVWXYZ

Italic

ABCDEFGHIJKLMNOPQRSTUV

Bold

ABCDEFGHIJKLMNOPQRSTUVW

Bold Italic

ABCDEFGHIJKLMNOPQRSTUVWXYZ

Bold Condensed

ABCDEFGHIJKLMNOPQRS

Extra Bold

Illustrated above are six versions of the Gill Sans typeface.

73

A STANDARD ROMAN STYLE

The best groundwork for drawn lettering is to master a form of letter close to the classical Roman original: such a style is illustrated below and on the following pages. It contains all the accepted conventions about thicknesses of strokes, proportions of letters and presence of serifs. In fact, you will see that the stroke thicknesses correspond closely to what they would be in the corresponding pen letter, though these drawn letter styles cannot be reproduced by simple pen strokes: they have to be drawn in outline first. N.B. The axes of all round letters of the true Roman alphabet lie at a similar angle to those of the calligraphic letter. Some typefaces follow this rule; others have vertical axes like the one below.

vertical axis

true Roman axis

aAbBcCdD
eEfFgGhHil

j J k K l L m M
n N o O p P q Q
r R s S t T u U v V
w W x X y Y z Z

Capital letters, except for 'I' and 'J', fall roughly into four categories, all based on the square and the circle.

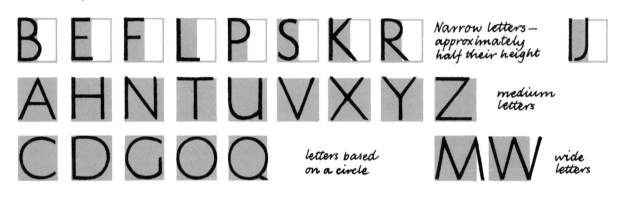

BEFLPSKR Narrow letters—
approximately
half their height IJ

AHNTUVXYZ medium
letters

CDGOQ letters based
on a circle MW wide
letters

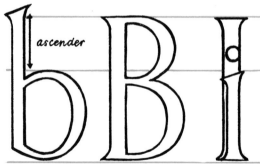

ascender

Capitals are generally marginally shorter than their corresponding lower case letters with ascenders. Slight variations in the actual ratios occur between different letter designs as do the widths of individual strokes in relation to the width of the letter. The strokes of capitals are slightly wider than those of their lower case counterparts.

DRAWING THE LETTERS

In the range of letters shown on the following pages, the ratio between ascender and non-ascender lower case letters is 10:6. Note the similarity with the proportions of the calligraphic round hand letters. The wide stroke of a capital is 1/8 of its height, with its narrow stroke 1/2 of this. As already observed, lower case strokes are slightly narrower. Each letter has been drawn within a square or, in the case of narrow capitals, a halved square, as a simple aid to proportion.

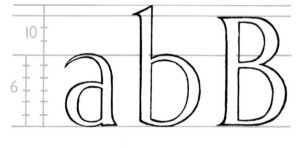

Draw each letter in pencil first, within the guidelines of the suggested proportions. It will help to ensure that thick and thin strokes are the correct thicknesses throughout if, right from the start, you mark their thicknesses on a scrap of paper and use this to set out the measurements of each letter in turn. A transparent set square set upon the baseline of the letters is useful when drawing the verticals. ACCURACY is very important.

Set Square

L.C.

Caps.

KEY TO MARKINGS

To aid you in drawing the letters, the large detailed version which follows has been marked up in a variety of ways. Thus:

Broken vertical lines indicate where tails and serifs extend beyond the upper part of the letter e.g. 'g', 'k', 'K', 'R' etc.

Dotted lines mark the widest point on the curve of a rounded letter e.g. 'c', 'O'.

A point marks the part of the letter which extends a fraction above or below its boundary line; this enlargement is necessary to counteract the optical illusion by which they appear smaller than adjoining letters e.g. 'A', 'o', 'v' etc.

Small dotted circles mark the approximate curve necessary for each serif. Simple straight edged serifs (see p. 66) are used throughout this standard style of letter

Equal - length horizontal arrows. The points of 'A', 'M', 'v', 'V', 'w', 'W' lie midway between the limits shown by the arrow heads.

Approximate angles are shown in the letters 'M' and 'W' for the sloping strokes. A protractor will help initially but should become unnecessary with practice.

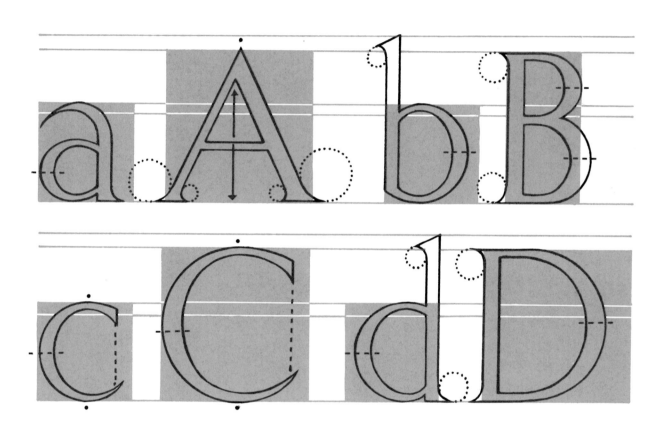

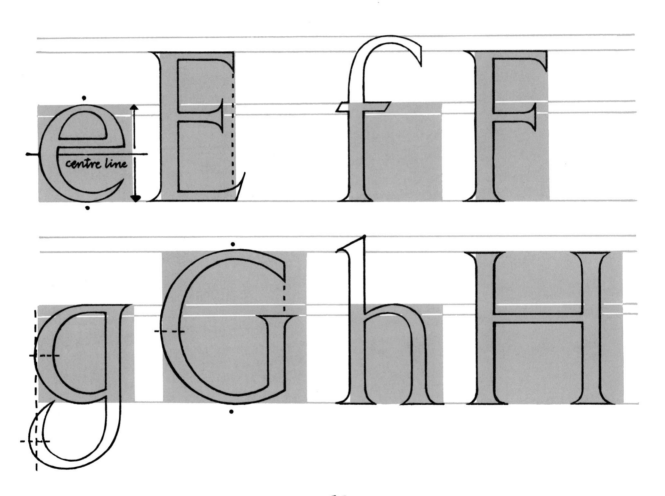

centre line

.80

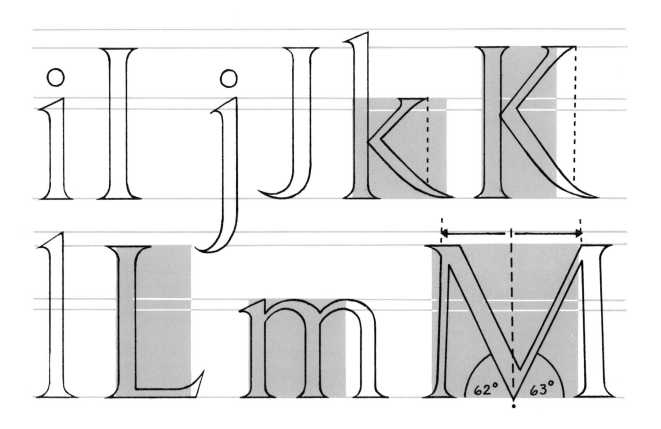

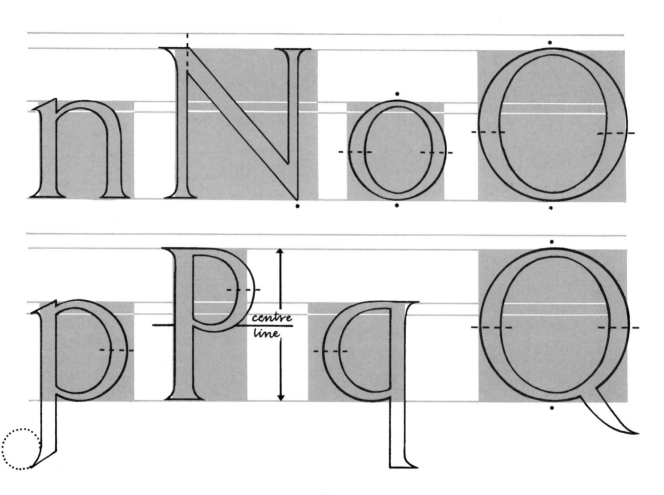

centre
line

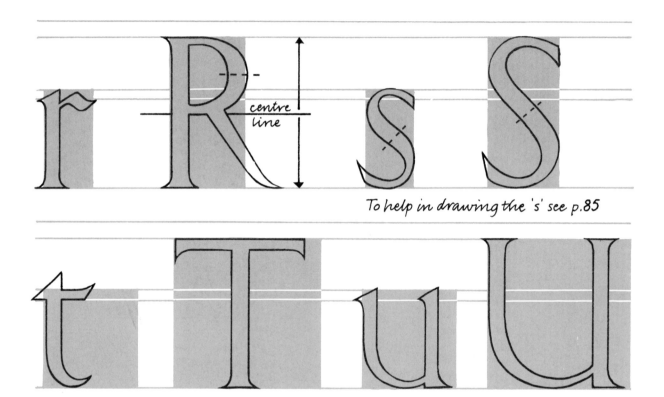

r R S

centre line

s S

To help in drawing the 's' see p.85

t T u U

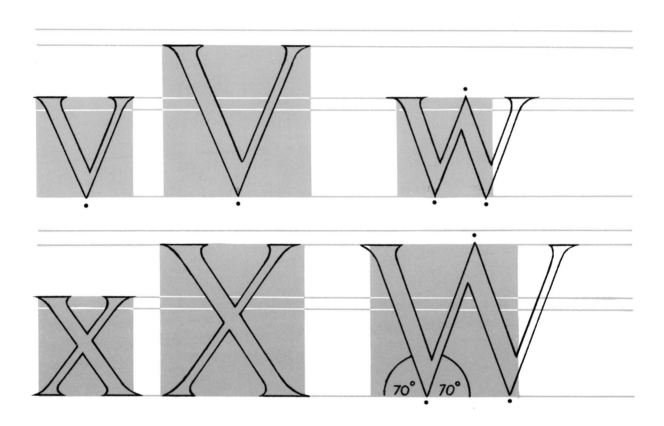

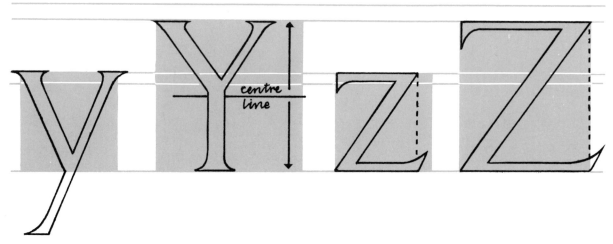

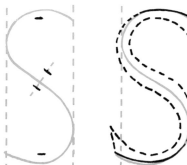

Most of the letters are fairly straightforward but the 's' may prove troublesome. The easiest way to draw it is to sketch in the basic shape with a single line, adding the measurements for the thicknesses to this. Note that the centre measurement straddles the line at RIGHT ANGLES. Complete the letter as shown by the dotted lines.

ITALIC DRAWN LETTERING

Unlike italic pen letters, drawn italic letters are not necessarily compressed laterally, but the letters illustrated here are occupying areas only $^4/_5$ the width of the upright letters already described. Consequently, all the characters are marginally narrower in proportion to their height, and the circular letters become oval. Again, thin and thick strokes can be narrower than in the upright style, though in this case they maintain the same 1:10 ratio for capital letters. Remember that capitals have slightly wider strokes than lower case letters, and that there are special forms for some small letters. To draw italic lettering use sloped guide lines as described on p.60. From these you can draw the appropriately tilted rectangles if you need them, but with practice the essential guidelines should be sufficient. Note that the axes of round letters now lie at the angle of the guidelines.

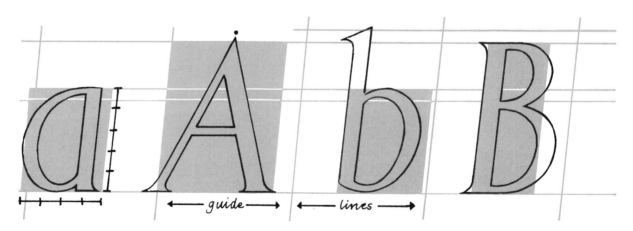

guide lines

86

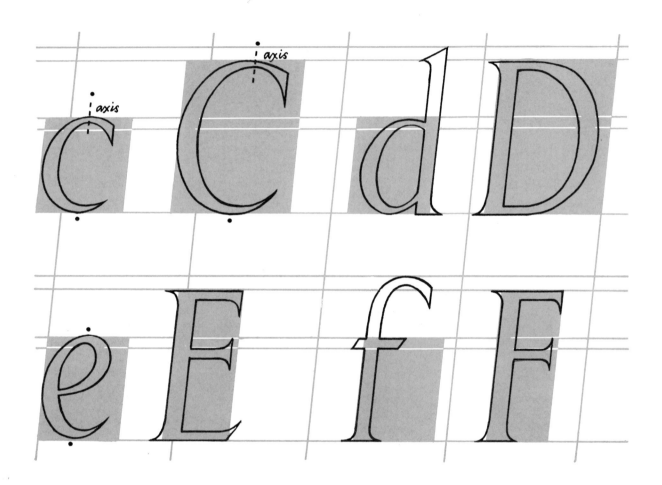

axis

axis

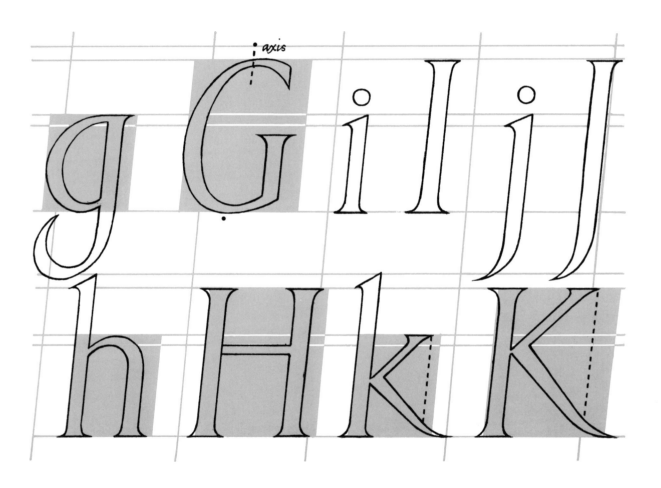

axis

88

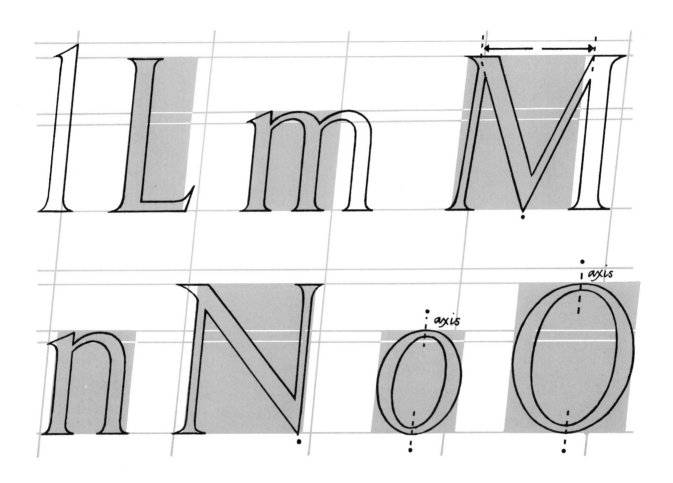

l L m M

n N o O

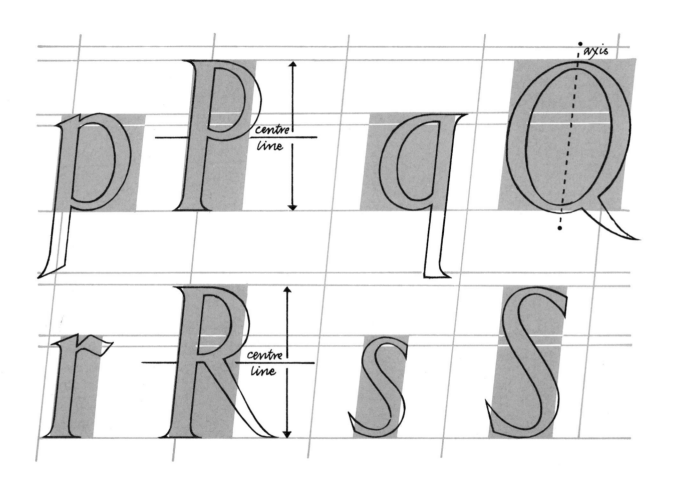

centre
line

axis

centre
line

90

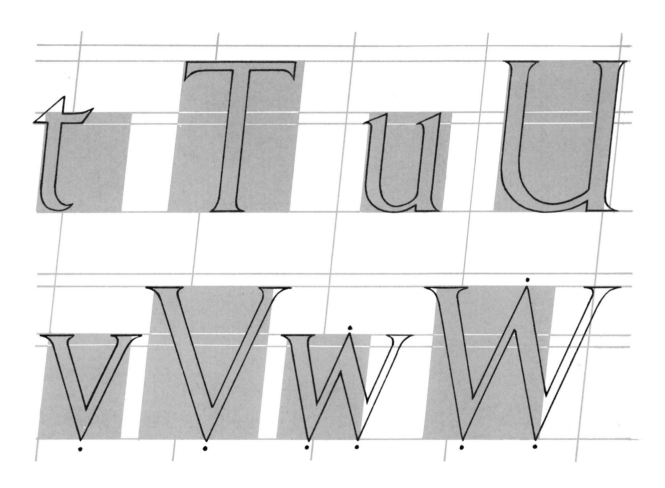

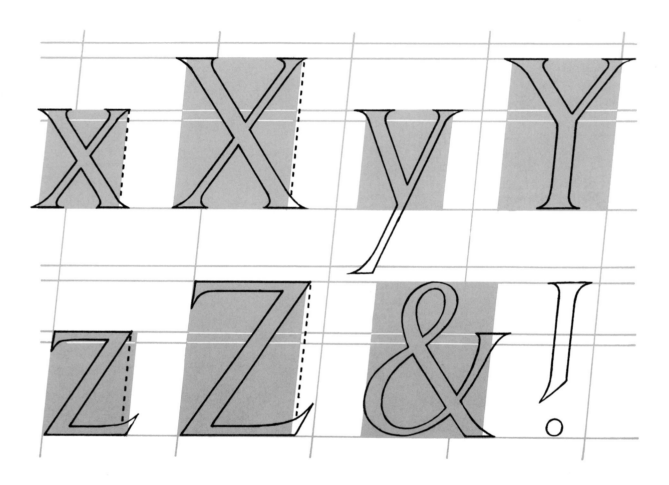

92

A 'PURE' ROMAN ALPHABET

Pure Roman capitals, like those used in classical inscriptions, particularly the splendid example on Trajan's column in Rome, are more complex and more difficult to draw than the letters of the deliberately simplified style described earlier. There are many variations of letter shape, but the example illustrated here shows typical features. Thus straight STROKES* thicken a fraction towards their extremities, SERIFS* are delicately modelled with a faint undulation replacing the straight edge, and, to counteract the illusion of appearing more fragile than other letters, ROUND LETTERS* have slightly thickened wide strokes. The AXES* of round letters, marked here with a broken diagonal, lie at an angle similar to those of the calligraphic letters.

Many excellent publications with comprehensive drawing instructions for Roman letters exist for students who wish to study them in depth. However, if careful attention is paid to the detailing of the letters illustrated here, an acceptable Roman can be achieved. Measurement and proportions are the same as for the simple letters. Take care never to exaggerate the gentle curves of strokes and serifs — they are only just perceptible, and must not interfere with the basic letter shape.

N.B. Some letters were either unknown, or were late importations to the Roman world. Furthermore, lowercase letters did not appear until about 200 A.D.

* For lower case letters to correspond with this Roman alphabet, simply modify the strokes, serifs and axes of the simple letters described on p.p 79-85 on the lines of the above Roman.

ABCD
EFGH

94

I J K L
M N O

PQRS
TUV

96

W X Y
Z & ! ?

NUMERALS

As in calligraphic numerals, drawn numerals can either be of uniform height, or can vary, depending on the particular numeral.

1234567890 *1234567890*
1234567890 *1234567890*

Numerals which are important to the understanding of a particular text should be the same size as the text capital letters.

4th September 10am - 4pm

CONDENSED LETTERING

When the width of each letter is reduced in relation to its height, the letters are said to be 'condensed'. Many serif and sans serif styles have condensed versions that enable a greater number of letters to be fitted into a given space : 'Compacta' illustrated opposite, is shown in full on p.128.

ABCDEF

Spacing out letters is done by 'eye' and requires practice and patience. The SPACES between each letter must be judged and made approximately equal. The difficulty is that the proportion of space varies according to the letters involved, and thoughtful planning is necessary before final drawing. In the days of mechanical typesetting the spacing between letters could only be widened; computer typesetting has changed all this but designers still need to train their eye to space letters in special headings or book titles.

ONLY ONLY

These are good – the space areas are optically even in size.

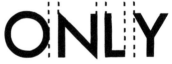

This is poor. Leaving an equal space between the BOUNDARIES of each letter does not work.

When a very wide space is unavoidable, as between the letters 'T' in the example below, these characters should be placed as closely together as possible, and the spaces between the other letters enlarged slightly to give an even effect. In drawn lettering, letters may be slightly narrowed, or serifs shortened, to ease spacing.

BUTTER

DECORATIVE DRAWN LETTERING

As in calligraphy, you can add decorative flourishes to drawn letters, provided the legibility of the letter is not affected. A decorative alphabet is shown below, and some finished examples can be seen on the following pages.

aA 6B cC dD eE fF gG

hHi I jJ kK lL mM n

NoO pP qQ rR sS tT uU

vV w W xX y Y z Z

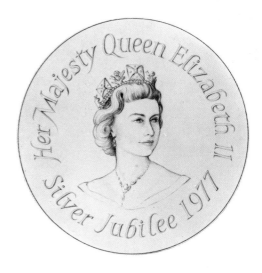

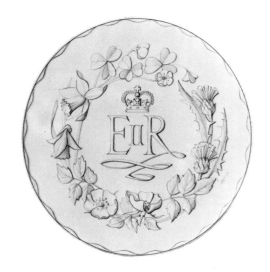

Silver Jubilee Commemorative Medal design using decorative italic drawn letters.

THE FRIENDS OF
CATHEDRAL
MUSIC

Please take this leaflet

J. FREEMAN

Festival of Flowers
in York Minster
1972

SEE ROUND

The St. Albans Diocesan Leaflet

The Alban Singers

Examples of drawn lettering combined with design and displaying the use of counterchange i.e. the designs contrast dark on light with light on dark motifs.

PLANNING A PIECE OF LETTERING

Drawn lettering provides wide scope for the artist because of the variety of designs available. A selection is given on the final pages of this book. Choose a design in keeping with the subject matter: a modern face such as 'Dom Casual' (p. 122) would be more in keeping with an advertisement for a jazz concert than would a Roman style typeface.

Having decided on the style of letter, you must also consider the use of lower case or capitals, or both, IN CONJUNCTION WITH any illustrations if necessary. Begin with small preliminary sketches, in colour if this is to be used, and IN PROPORTION WITH THE FINAL REQUIREMENTS. From these rough layouts, a full-sized, accurate layout can be drawn up, from which a transfer to the final sheet can be made — see opposite.

USEFUL MAXIMS

Do not draw text lines for letters until single line outlines, accurate in both spacing and proportion, have been indicated. Only then can the exact height of the letters be estimated within the space available.

In general, avoid isolating short words such as 'a', 'the', 'and' on lines to themselves.

Text made up of capitals and lower case letters 'reads' better from a distance than capitals by themselves.

Legibility is very important and complicated letter designs, or lettering which reads downwards, should be avoided.

Never add a full stop to a title, or dot a capital 'I'.

HOW TO TRANSFER A DESIGN

No design should be worked out on the final sheet of paper because rubbing out would damage the paper surface. The design should be made on smooth-surfaced paper, from which it can be transferred to the final sheet, either from a tracing or the artwork itself. To do this, take the tracing or the artwork and scribble over the back of the sheet with a soft, black pencil. If the design is to be transferred onto a dark ground use white or light coloured chalk instead of a pencil. Then rub the scribble over with a scrap of tissue or blotting paper to make, in effect, mock carbon paper. Fix this sheet, scribbled side down, on the final sheet and draw VERY CAREFULLY over the design using a sharp, hard pencil. Use a ruler if there is lettering. Once everything has been drawn through, remove the transfer and lightly re-draw the text lines for any lettering; no transfer will be completely accurate, however carefully it has been done and you may need to retouch the finer details of the design.

N.B. NEVER use real carbon paper; mistakes from this cannot be erased.

PAINTED BACKGROUNDS

A background can be completely painted before lettering is superimposed upon it, but over-painting is more tricky as the undercolour tends to lift.

ALTERATIONS AT THE TRANSFER STAGE

Some alteration to the design can be made quite easily at the transfer stage. For example, you can cut out the offending words or letters or part of the design and tape the correction into position. Transfer in the usual way.

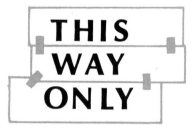

TRANSFERRING FROM A SMALL TO A LARGE SHEET

If the paper from which you are transferring a design is smaller than the final sheet, you can prevent damage to the latter by attaching strips of paper to the edges of the transfer sheet, thus extending its dimensions. The ends of the strips should extend beyond the final sheet, enabling them to be fixed to the board.

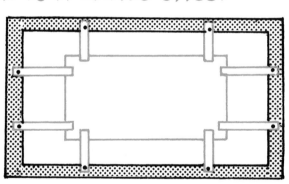

SPEEDY MEASURING

The simplest method of finding the centre of any given space or line is to indicate its full extent on a long strip of paper and fold it in two, placing the marks together. The crease marks the centre.

ENLARGING

To enlarge a rectangle in correct proportion to itself, extend one diagonal of the original. Complete the new rectangle from any point on this EXTENDED line.

To obtain a smaller rectangle in proportion to the original, complete a new rectangle from any point on the diagonal WITHIN the original.

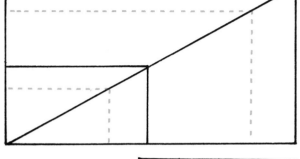

To transfer a design from a small original to an area enlarged in the correct proportions, both the original drawing and the enlarged area must be squared up. Draw a series of lines either on the original itself, or on a piece of tracing paper that should be fixed firmly to the original. (See illustration.) If the drawing to be copied is very complex, continue drawing lines until the sections are very small. Draw an EQUAL NUMBER of lines in exactly the same manner on the larger area. The design visible in each section of the original can now be copied into the appropriate larger one.

PAINTING

In any piece of design work, mix MORE THAN SUFFICIENT paint of each colour to be used. Keep the surplus paint until the work is completed to cater for any necessary re-touching. Mixed paint should be kept in airtight containers. Should the paint dry out, and providing it is water-based, the addition of a small amount of water should make it usable again.

When painting a neat edge always draw the brush along sideways with its bristles lying against the edge line. Keep turning the drawing board so that the brush is always in the correct position. Do not overfill the brush with paint.

REMOVING MISTAKES IN PAINTING

Very thin watercolour can be almost entirely removed by using a soft PENCIL eraser when the paint is thoroughly dry. Thicker watercolour paint or water-based poster-colour should be dampened with a wet brush first, and then absorbed by blotting paper. Repeat until no more colour can be removed. Allow to dry thoroughly after which re-painting should be possible, or the area can be further cleaned by using a soft pencil eraser.

WARPING : THE NEED TO 'STRETCH' PAPER

If thin watercolour is used in quantity on paper not specifically treated, the paper will warp during drying. 'Stretching' it prevents this, and will also provide a better working surface. Even when using a thicker product such as poster-paint which causes little warping—the improved, smooth working-surface may be worthwhile.

HOW TO STRETCH PAPER

You will require: a clean, well scrubbed drawing board; sufficient gummed paper tape (50mm (2") wide to extend round the circumference of the board) and cut into appropriate lengths; drawing pins; and the paper to be stretched which must be a little smaller than the board.

1. Wet BOTH sides of the paper thoroughly by holding it under a running tap.
2. Lay the paper carefully on the board, raising it and replacing it again to release any large air bubbles. Smaller ones will disappear during drying.
3. In turn, moisten each strip of gummed paper, and place them along the board edges, half on the paper, half on the board.
4. Reinforce the paper tape WHERE IT LIES ON THE PAPER by evenly placed drawing pins. (Drawing pins alone may be substituted for the paper tape, provided a large number is used, for example at 20mm (2/3") intervals. Insert them at an angle, to help restrain the drying contraction).
5. Place the board to dry at room temperature. It may take several hours. When dry, the pins may be removed, BUT ONLY IF USED ALONG WITH GUMMED TAPE.

N.B. The paper is cut from the board only when the design work has been completed. Any repainting done after the paper has been removed from the board will cause warping.

MARGINS AND MOUNTING

The width of a margin round a piece of work, or the width of the mount, can make or mar the finished result. If you follow a few simple rules you should have no problems.

It is generally accepted that the base border should be the widest, with the top border and sides slightly narrower than the base. Experiment with various alternatives until the whole looks right. If the borders are too narrow, the work will look cramped; if they are too wide, the work will be lost. Sometimes work can be mounted any size you wish; more often, perhaps, you will have to work to a fixed final size and the design area must be adjusted before any work is done to allow for appropriate margins.

For protection, any good piece of work should be attached to a stiff piece of card, which may in some instances also provide the margin. One of the easiest ways of fixing is to use a length of double-sided adhesive tape along the top edge only; alternatively use a non-staining glue.

HOW TO CUT A WINDOW MOUNT

Sometimes it is an improvement to use a 'window' mount – possibly in a contrasting colour. Here the drawing – already attached to a piece of stiff backing card as described above – is seen through a hole cut in the upper mount. This method is normal when framing behind glass.

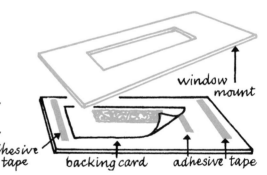

window mount

adhesive tape backing card adhesive tape

To mark the area to be cut out, the exact size of the design must be transferred to the mounting card. To do this, cut four narrow strips of paper with accurate, straight edges, and lay them round the design, taping them together when in place. This will now have the exact dimensions. Lay it on the mounting card and mark in the dimensions in pencil.

The area to be cut out must, of course, be a little larger than the design itself. The space between the edge of the mount and that of the design is a matter of taste but 10mm (1/2"), with slightly more at the base is a good average. Mark the dimensions carefully with a sharp pencil.

Cut out the area inside the rectangle using a very sharp, strong knife and steel rule. To be correct, the knife should be held at an angle, to give a bevelled edge sloping inwards, but this is difficult and requires practice. Lay the rule on the border when cutting – this will ensure that if the knife should slip, the area to be cut out will be damaged, and not the border itself.

The mount should be attached along the top and the base, to the BACKING CARD, not to the work itself.

PUTTING ON A WASH

A variety of coloured papers is available for design work; alternatively you can tint a paper by putting on a 'wash' of thin colour. To be successful this requires a little practice, for although the technique is simple, speed is essential. It should be carried out on 'stretched' paper unless it is a specially manufactured watercolour paper.

1. Mix up more than enough watery paint – with experience you will be able to judge your requirements.
2. Place the board, with the paper attached, on your knee, against a table, at the same angle as you would for pen lettering.
3. Charge the brush with paint – a large, bushy wash-brush is best – and draw it swiftly across the top of your panel, taking care to fill up to corners and edges.
4. Repeat, recharging your brush if necessary, but this time a little lower down the paper and catching the lower edge of the previous paint line with your brush. Be careful not to let the watery paint run down the page; your brush must be full but not dripping.
5. Continue to the end of the section you wish to paint, maintaining parallel and horizontal strokes. Finally, squeeze your brush dry, and with it soak up any excess paint which may be lying along the baseline. N.B. NEVER repaint any section or touch up any mistakes – they will show.

If, after following these instructions, you still cannot obtain an even wash, try dampening the whole wash area with clean water immediately before starting to apply the wash.

FORMING OTHER STYLES OF LETTER

When the proportions of the Roman-style letters have been mastered, you should have little trouble tackling other typefaces with widely differing characteristics. Below are some examples with a similar width to height ratio. The variations between the thick and thin strokes in sans serif faces are either non-existent or very slight.

AB AB AB AB AB AB

Albertus — Futura Light — Beton Bold

TYPEFACES

The following typefaces are a small but varied selection of serifed, sans serifed and decorative faces which should fulfil basic requirements. Typefaces are still being designed, and some modern versions are included.

To supplement these, you can make your own collection of typefaces from magazine and newspaper cuttings. Try to obtain as many letters from each range or 'fount' as you can.

SANS SERIF SHADOW

A B C D E F G H I J;

K L M N O P Q R S T

U V W X Y Z - 1 2 3 4

5 6 7 8 9 0 ! & ? £ $ °

DAVIDA

ABCDEFGHIJ
KLMNOPQRS
TUVWXYZ~12
34567890&?!;

ABCDEFGHIJKLMNOP‹›

QRSTUVWXYZ~abcdefg

hijklmnopqrstuvwxyz;123

4567890&?!£$·

ABCDEFGHIJKLMNO.

PQRSTUVWXYZ~abc‹

defghijklmnopqrstuv‹›

wxyz;1234567890&?!£$

RAPHAEL

ABCDEFGHIJKLMNO<>

PQRSTUVWXYZ~abcd

efghijklmnopqrstuvwx

yz;1234567890&?!£$-().

GALLIA

A A B C D E E F G
G H I J K L M N S;
O P Q R R S S T 4
U V W X Y Z 1 2 3

ABCDEFJGHH

IJKKLLLMNOPQ

RSTTUVWYZ.

ABCDEFGHIJKLMNOP

QRSTUVWXYZ~abcdefg

hijklmnopqrstuvwxyyz«»

1234567890&?!£$()_;

121

DOM CASUAL

ABCDEFGHIJKLMNOPQRS‹›

TUVWXYZ~abcdefghijklmno

pqrstuvwxyz;1234567890&

?!£$()«».

BROADWAY ENGRAVED

ABCDEFGHIJK~

LMNOPQRSTU◦

VWXYZ~123456

7890&?!!£$%():;"

ABCDEFGHIJKLMN
OPQRSTUVWXYZ-a.
bcdefghijklmnopqrstu
vwxyz1234567890&?!

ABCDEFGHIJKLMN«

OPQRSTUVWXYZ~a

bcdefghijklmnopqrstu;

vwxyz1234567890&?!()»

FUTURA DISPLAY

ABCDEFGHIJKLMNOPQ»

RSTUVWXYZ~abcdefg;

hijklmnopqrstuvwxy

z1234567890&?!£$()«

EUROSTILE MEDIUM

ABCDEFGHIJKL,

MNOPQRSTUV«»

WXYZ~abcdefgh

ijklmnopqrstuvwx

COMPACTA BOLD OUTLINE

ABCDEFGHIJKLM ;

NOPQRSTUVWXYZ

1234567890&?!~

£$«»».